Spirit of the
Wolf

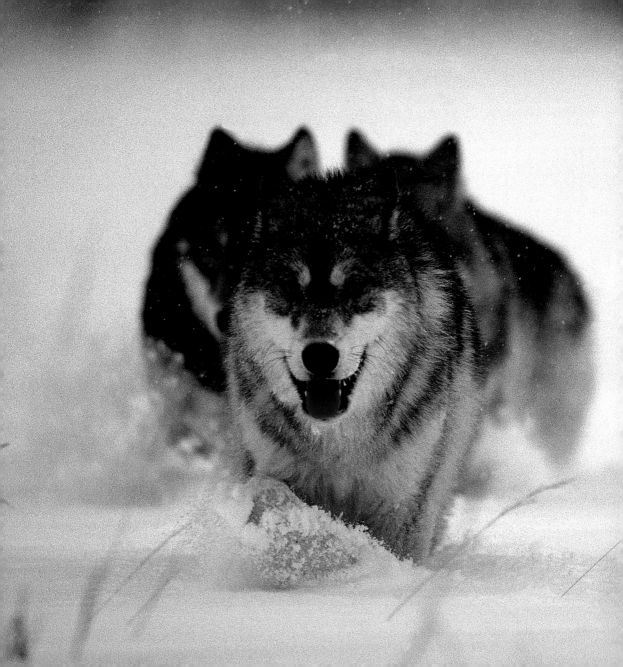

Spirit of the
Wolf

WILLOW CREEK PRESS®

Published by Willow Creek Press, Inc.
P.O. Box 147, Minocqua, Wisconsin 54548

Photo Credits:

p2-3 © Minden Pictures/Masterfile; p5 © Minden Pictures/Masterfile; p6-7 © Minden Pictures/Masterfile; p8 © Minden Pictures/Masterfile; p15-16 © Minden Pictures/Masterfile; p20-21 © Minden Pictures/Masterfile; p23 © Raimund Linke/Masterfile; p24-25 © Minden Pictures/Masterfile; p27 © AlaskaStock/Masterfile; p28-29 © Minden Pictures/Masterfile; p32-33 © Minden Pictures/Masterfile; p40-41 © F. Lukasseck/Masterfile; p42-43 © Tim Fitzharris; p44-45 © Minden Pictures/Masterfile; p47 © Minden Pictures/Masterfile; p51 © Minden Pictures/Masterfile; p52-53 © Minden Pictures/Masterfile; p55 © Minden Pictures/Masterfile; p60 © Christina Krutz/Masterfile; p62-63 © Minden Pictures/Masterfile; p64 © Minden Pictures/Masterfile; p68 © Minden Pictures/Masterfile; p74-77 © Tim Fitzharris; p79 © Tim Fitzharris/Masterfile; p80-81 © Tim Fitzharris; p83 © Minden Pictures/Masterfile; p84-85 © F. Lukasseck/Masterfile; p87 © Minden Pictures/Masterfile; p88-89 © Mike Macri/Masterfile; p90-91 © AlaskaStock/Masterfile; p92 © Tim Fitzharris; p94-95 © Minden Pictures/Masterfile;

Design: Donnie Rubo
Printed in Canada

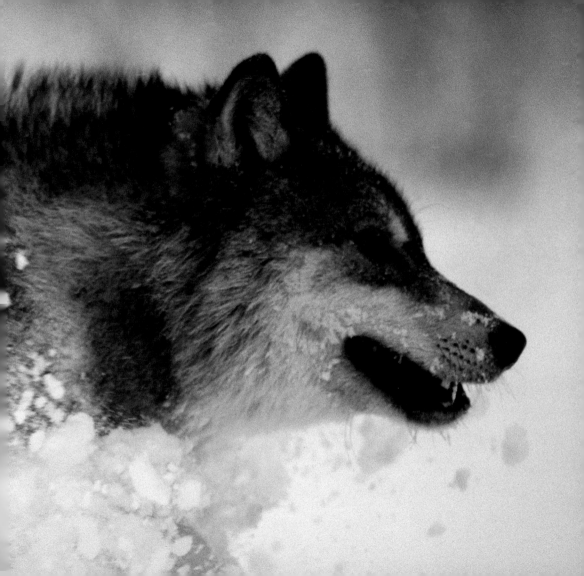

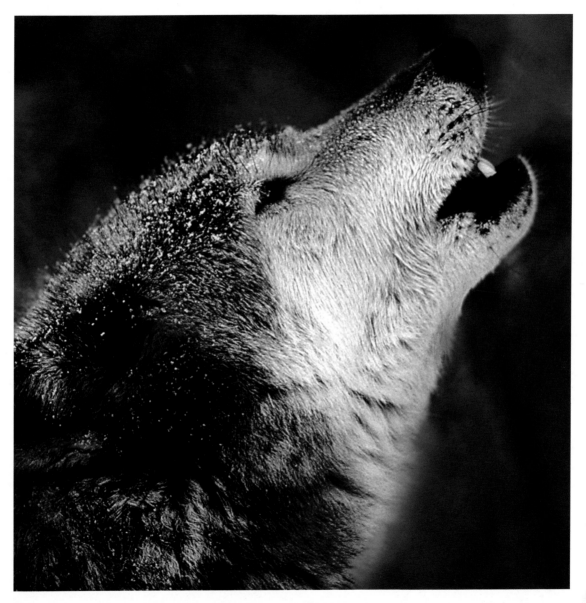

A deep chesty bawl echoes

FROM RIMROCK TO RIMROCK, ROLLS

DOWN THE MOUNTAIN, AND FADES

INTO THE BLACKNESS OF THE NIGHT.

IT IS AN OUTBURST OF WILD DEFIANT

SORROW, AND OF CONTEMPT FOR

ALL THE ADVERSITIES OF THE WORLD...

...EVERY LIVING THING
(AND PERHAPS MANY
A DEAD ONE AS WELL)
PAYS HEED TO THAT CALL...

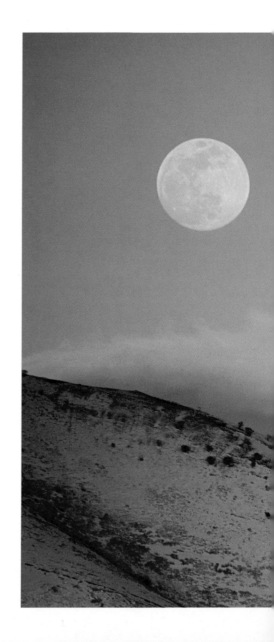

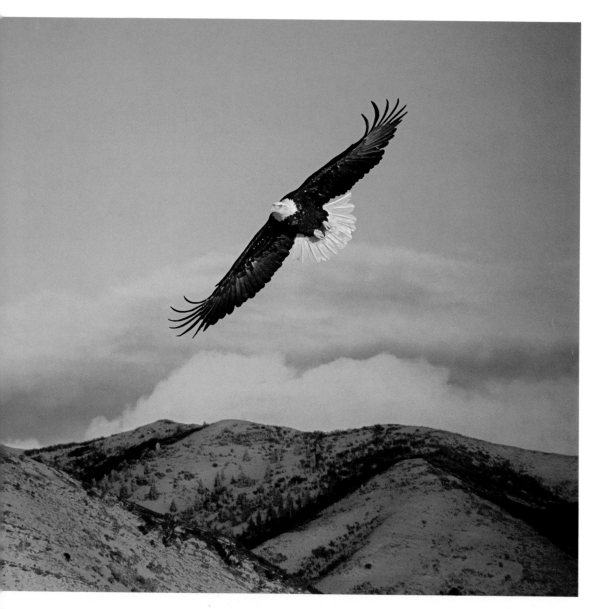

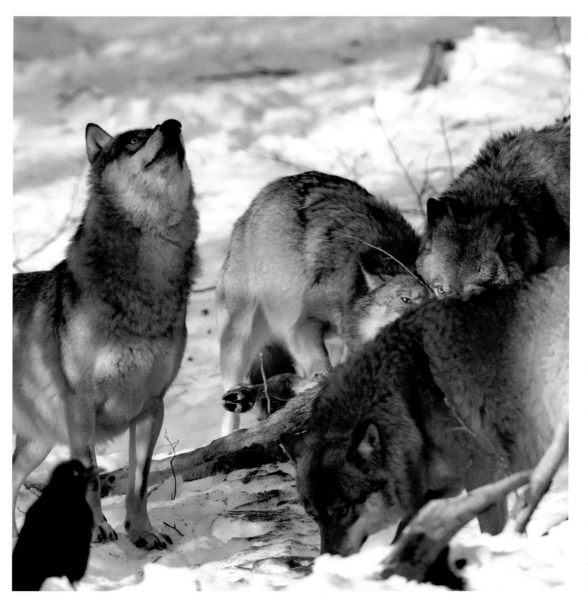

...TO THE DEER IT IS A REMINDER
OF THE WAY OF ALL FLESH, TO THE
PINE A FORECAST OF MIDNIGHT
SCUFFLES AND BLOOD UPON THE
SNOW, TO THE COYOTE A PROMISE
OF GLEANINGS TO COME...

YET BEHIND THESE OBVIOUS AND IMMEDIATE HOPES AND FEARS THERE LIES

A *deeper meaning,* KNOWN ONLY TO THE MOUNTAIN ITSELF.

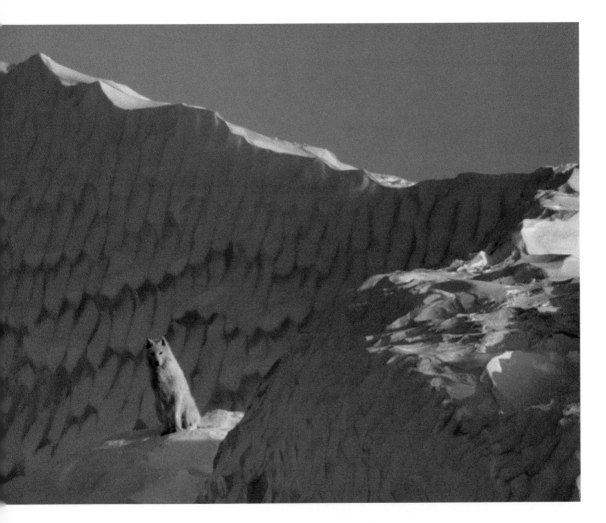

ONLY THE MOUNTAIN HAS LIVED LONG ENOUGH TO

LISTEN OBJECTIVELY TO THE *howl of a wolf.*

[ALDO LEOPOLD]

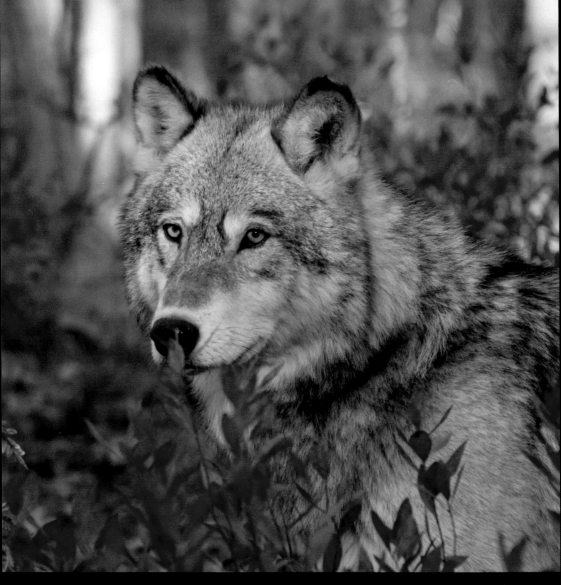

WE HAVE TODAY TO LEARN TO GET BACK

INTO ACCORD WITH THE WISDOM

OF NATURE AND REALIZE AGAIN

our brotherhood

WITH THE ANIMALS...

THE IDEA IS TRANS-THEOLOGICAL.

IT IS OF AN UNDEFINABLE,

INCONCEIVABLE MYSTERY,

THOUGHT OF AS A POWER,

THAT IS THE SOURCE AND END

AND SUPPORTING GROUND

OF ALL LIFE AND BEING.

[JOSEPH CAMPBELL]

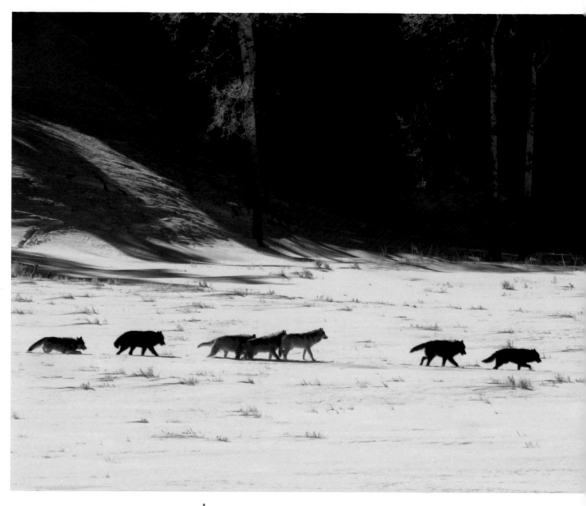

Wolves ARE NOT OUR BROTHERS;
THEY ARE NOT OUR SUBORDINATES, EITHER.

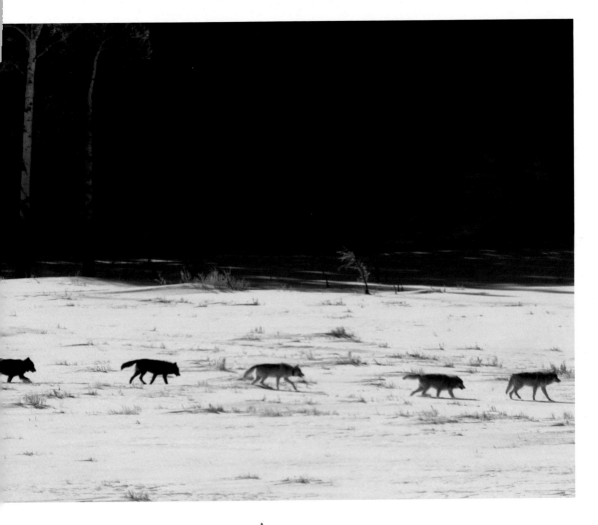

THEY ARE *another nation,* CAUGHT UP
JUST LIKE US IN THIS COMPLEX WEB OF TIME AND LIFE.

[HENRY BESTON]

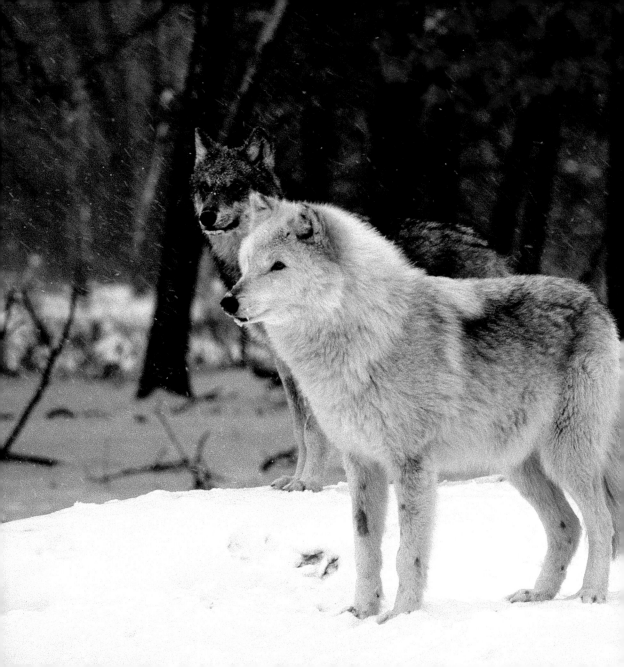

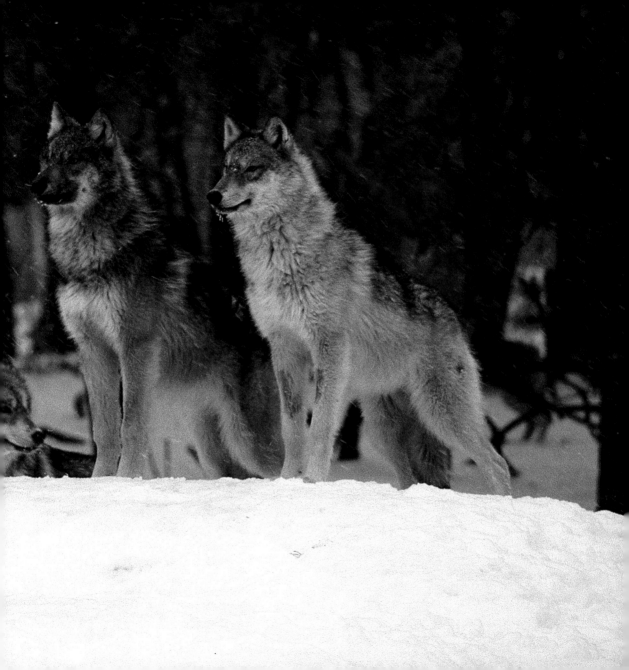

AND EVERYONE BELIEVES TO SOME DEGREE
THAT WOLVES HOWL AT THE MOON, OR
WEIGH TWO HUNDRED POUNDS, OR TRAVEL
IN PACKS OF FIFTY, OR ARE DRIVEN CRAZY BY
THE SMELL OF BLOOD. NONE OF THIS IS TRUE.
THE TRUTH IS WE KNOW LITTLE ABOUT THE
WOLF. WHAT WE KNOW A GOOD DEAL
MORE ABOUT IS WHAT WE

imagine the wolf to be.

[BARRY LOPEZ]

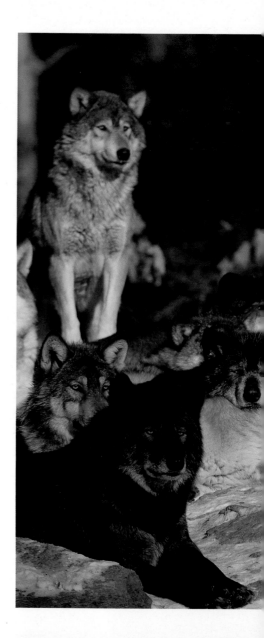

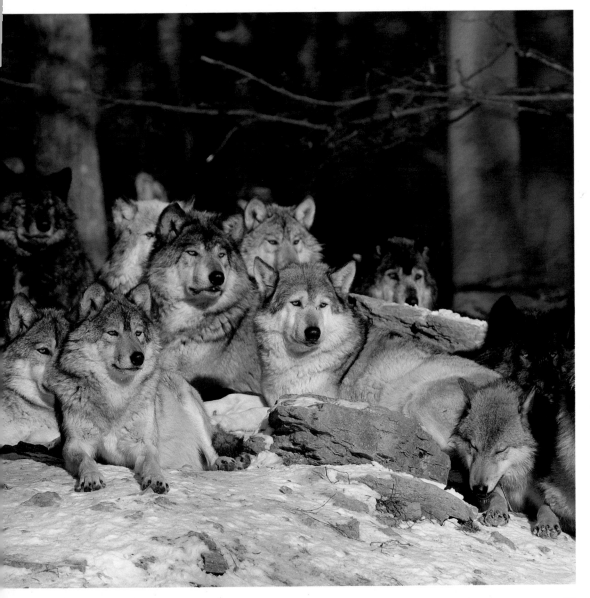

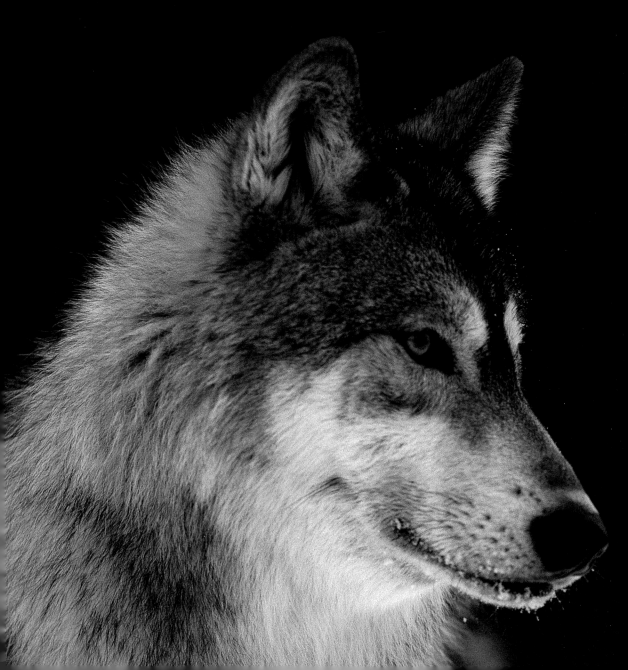

I GENUINELY BELIEVE A MAGIC EXISTS IN CREATURES

AS PERCEPTIVE AND INTELLIGENT AS WOLVES,

A MAGIC THAT IS LIKELY TO FOREVER ELUDE THE KIND

OF CLINICAL OBSERVATION PROVIDED BY RADIO COLLARS

AND SCAT MEASUREMENTS...

INDEED, I BELIEVE THAT WOLVES

possess a kind of spirit

WE CAN ONLY BEGIN TO UNDERSTAND

THROUGH OUR EMOTIONS.

[JIM BRANDENBURG]

WE NEED ANOTHER AND A WISER AND PERHAPS

A MORE *mystical* CONCEPT OF ANIMALS.

[HENRY BESTON]

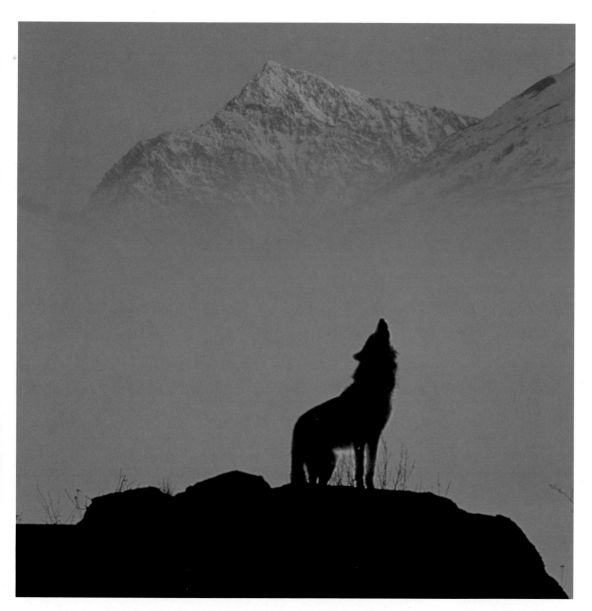

THE BEST WOLF HABITAT RESIDES IN THE *human heart.*

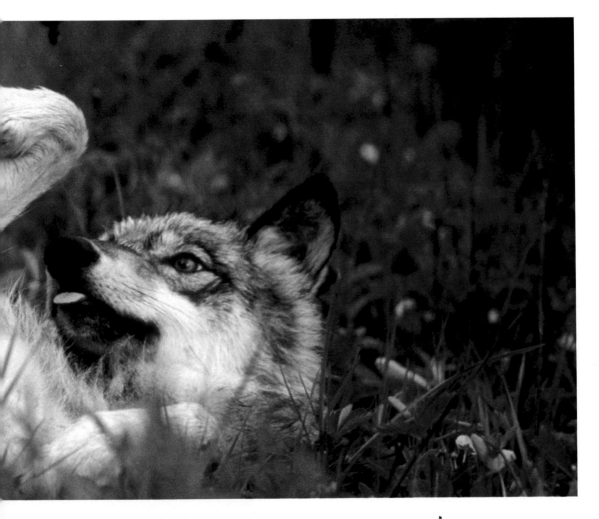

YOU HAVE TO LEAVE A LITTLE SPACE FOR THEM TO *live.*

[ED BANGS]

WE CALL UPON THE
CREATURES OF THE FIELDS AND
FORESTS AND THE SEAS, OUR

brothers and sisters

THE WOLVES AND DEER,
THE EAGLE AND DOVE...
AND WE ASK THEM TO TEACH
US, AND SHOW US THE WAY.

[CHINOOK BLESSING]

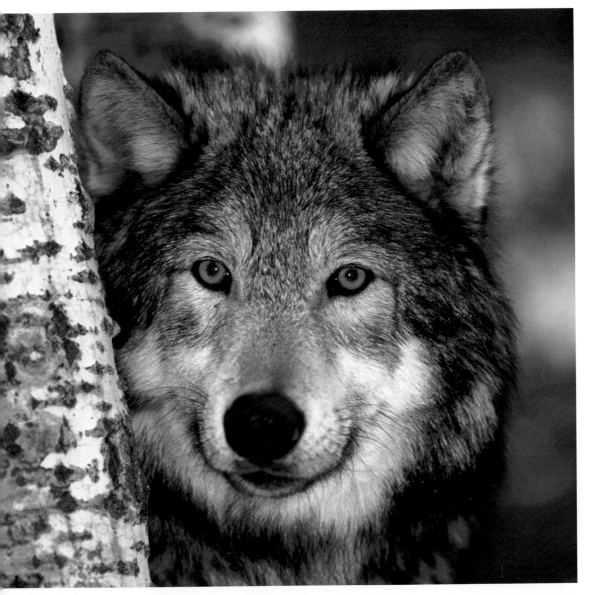

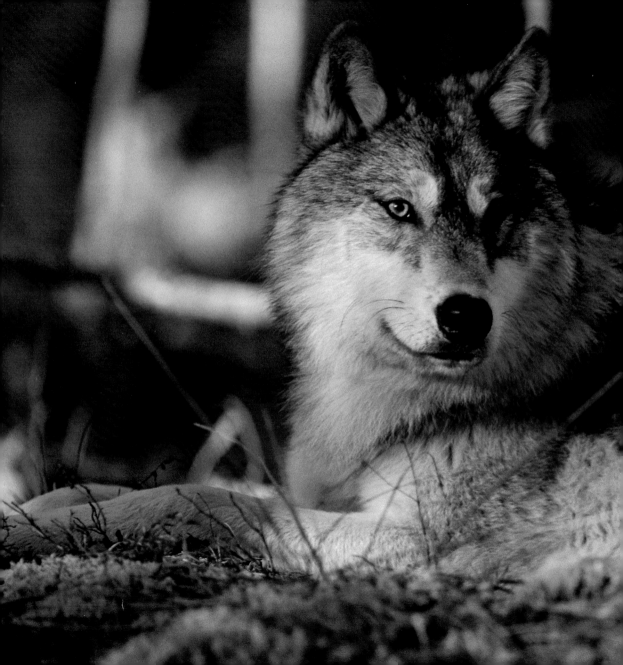

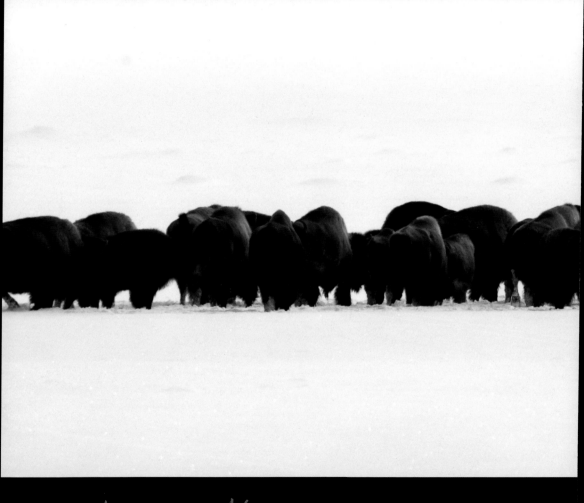

A *hungry wolf* AT ALL THE HERD WILL RUN, IN HOPES,

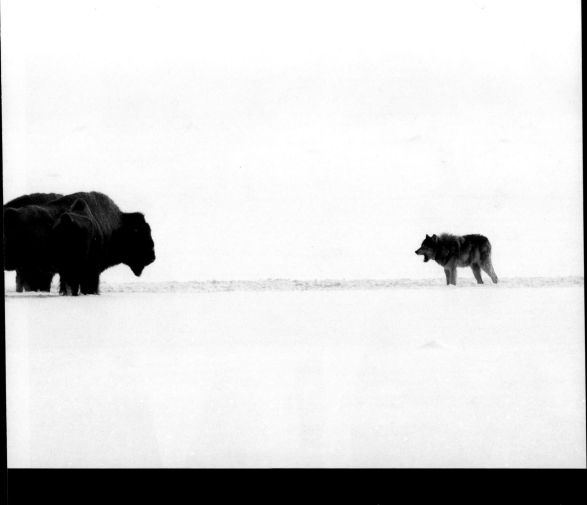

THOUGH MANY, TO MAKE SURE OF *one.*

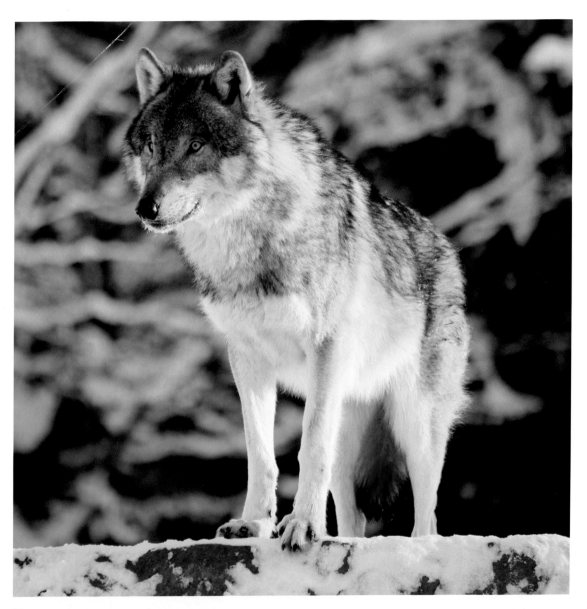

IF ALL THE BEASTS WERE GONE,

MEN WOULD DIE FROM A GREAT

loneliness of spirit,

FOR WHATEVER HAPPENS TO THE BEASTS

ALSO HAPPENS TO THE MAN.

ALL THINGS ARE CONNECTED.

WHATEVER BEFALLS THE EARTH

BEFALLS THE SONS OF THE EARTH.

[CHIEF SEATTLE]

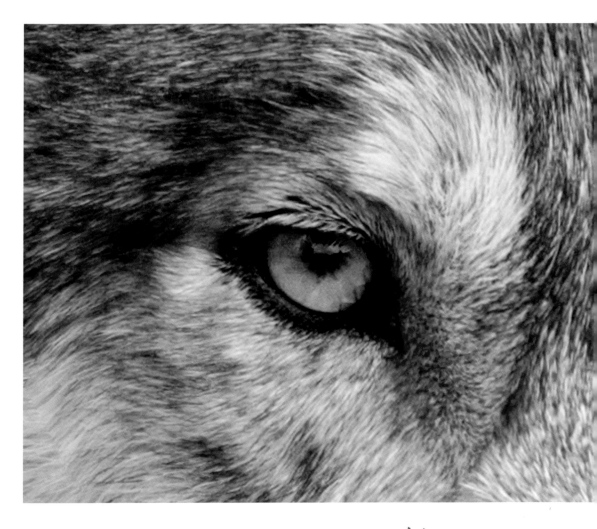

TO LOOK INTO THE EYES OF A *wolf*

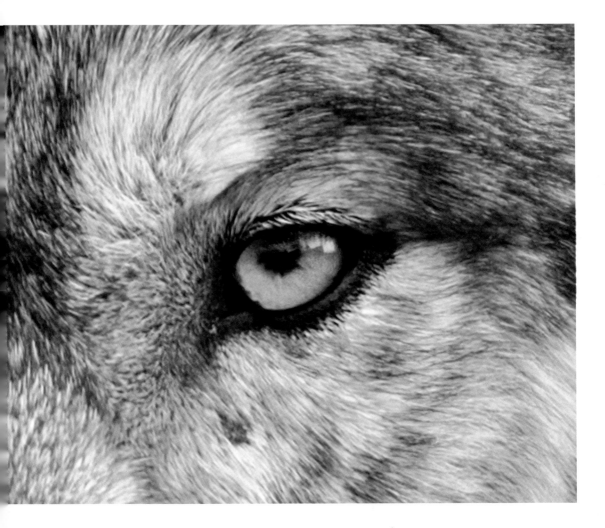

IS TO SEE YOUR OWN *soul.*

[ALDO LEOPOLD]

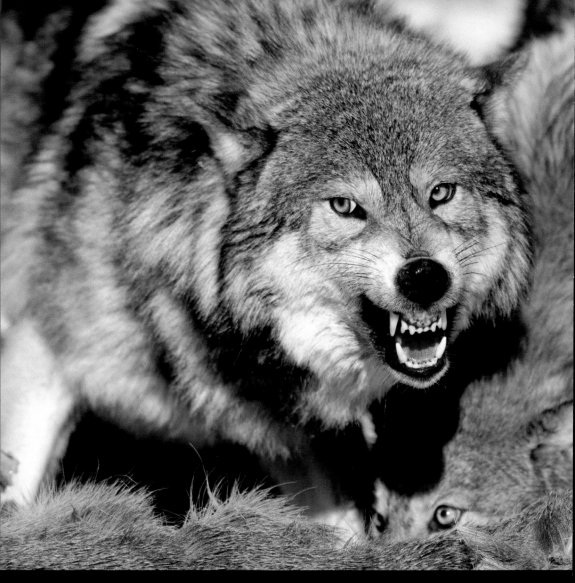

NATUR

GIVES

MEA

makes

NEVER

WITH M

INFRING

IT IS A H

ARE HA

THE FOU

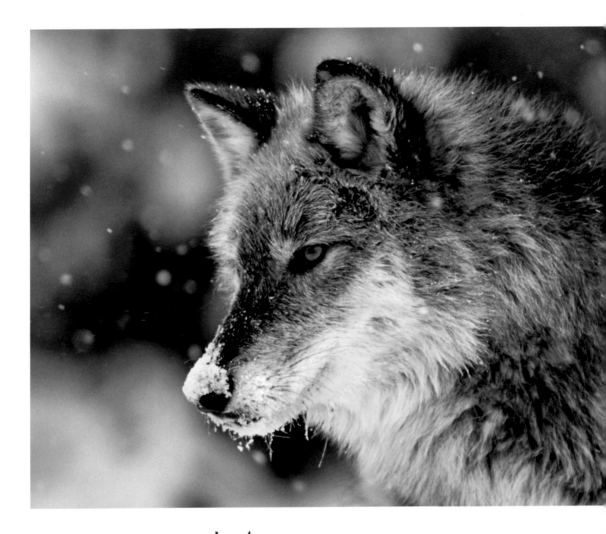

YOU CAN *look* AT A GRAY WOLF STANDING IN THE SNOW IN WINTER TWILIGHT AND NOT SEE HIM AT ALL...

SOMETIMES EVEN THE *Eskimos* CAN'T SEE
THEM, WHICH CAUSES THE ESKIMOS TO SMILE.

[BARRY LOPEZ]

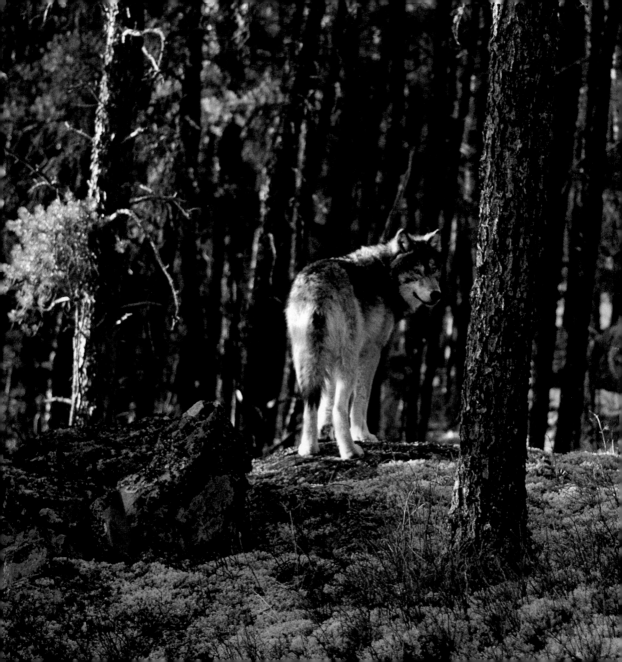

LET A MAN DECIDE UPON HIS FAVORITE

ANIMAL AND MAKE A STUDY OF IT,

learning its innocent ways.

LET HIM LEARN TO UNDERSTAND

ITS SOUNDS AND MOTIONS.

THE ANIMALS WANT TO

COMMUNICATE WITH MAN,

BUT WAKANTANKA DOES NOT INTEND

THEY SHALL DO SO DIRECTLY—

MAN MUST DO THE GREATER PART

IN SECURING AN UNDERSTANDING.

[BRAVE BUFFALO, TETON MEDICINE MAN]

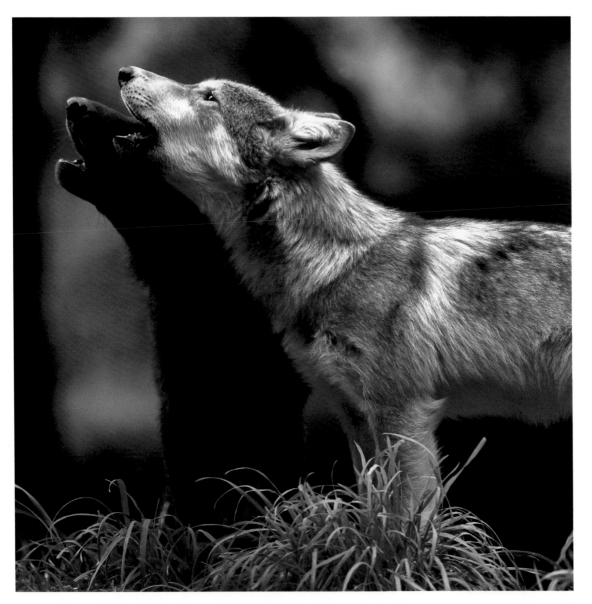

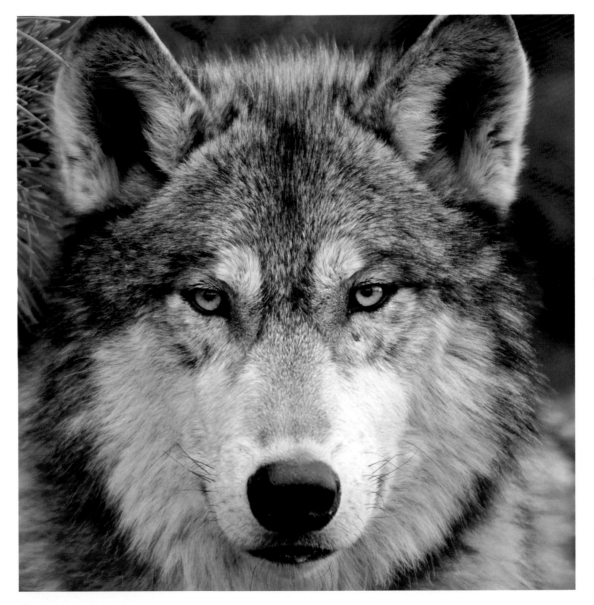

WE HUMANS *fear the beast* WITHIN THE WOLF
BECAUSE WE DO NOT UNDERSTAND THE BEAST WITHIN OURSELVES.

[GERALD HAUSMAN]

THE AWAKENING OF A BURIED WISH

FOR THE WILD FREEDOM OF REMOTE

ANCESTORS, THE MYSTERY OF AN ANIMAL

THAT RESPONDS TO US BUT WHICH WE

ALMOST NEVER SEE, THE THRILL OF DIRECT

COMMUNICATION WITH A LEGENDARY OUTLAW

THAT HAS RESISTED FOR CENTURIES OUR

EFFORTS TO DESTROY IT, THE MAGIC OF

a night in wolf country.

[DAN STRICKLAND]

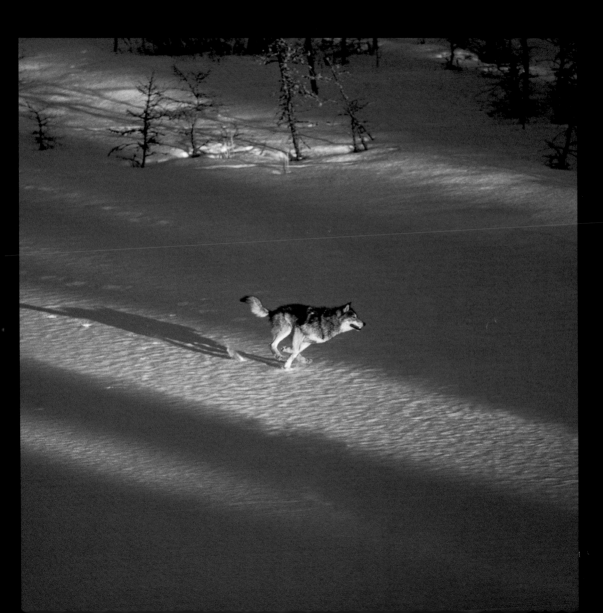

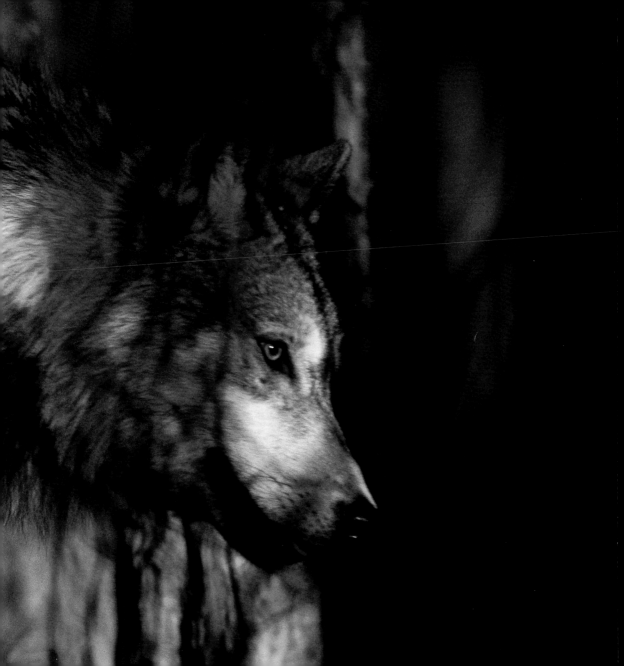

THE AIM OF LIFE WAS MEAT.

Life itself was meat

LIFE LIVED ON LIFE. THERE WERE

THE EATERS AND THE EATEN.

THE LAW WAS: EAT OR BE EATEN.

HE DID NOT FORMULATE THE LAW IN CLEAR,

SET TERMS AND MORALIZE ABOUT IT.

HE DID NOT EVEN THINK THE LAW;

HE MERELY LIVED THE LAW WITHOUT

THINKING ABOUT IT AT ALL.

[JACK LONDON, FROM WHITE FANG]

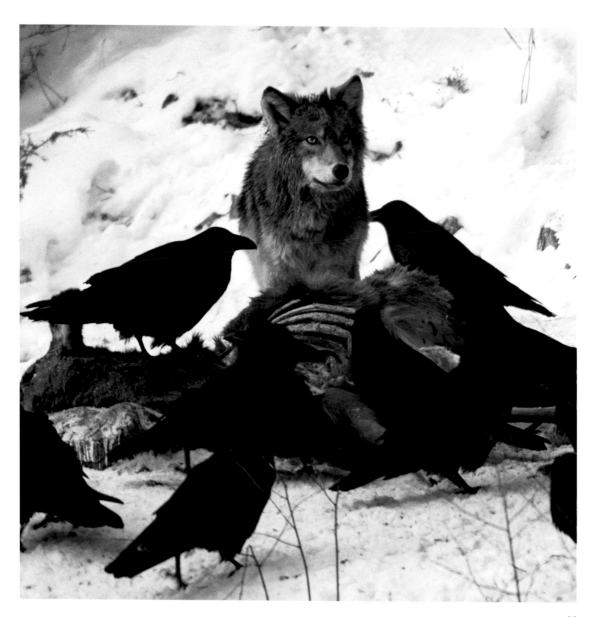

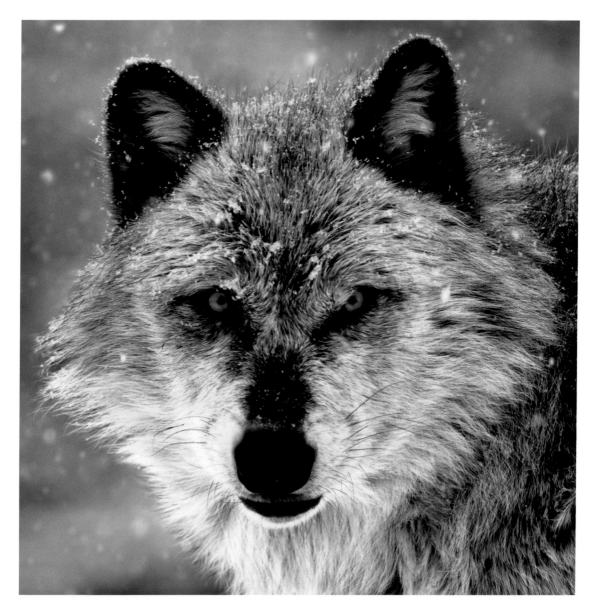

Fear MAKES THE WOLF BIGGER THAN HE IS.

[GERMAN PROVERB]

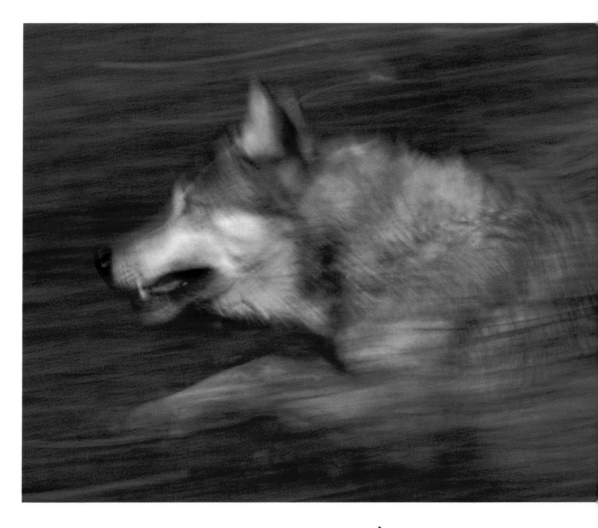

IN MOTION, THEY *ripple,*

THEY *flow.*
[LOIS CRISLER]

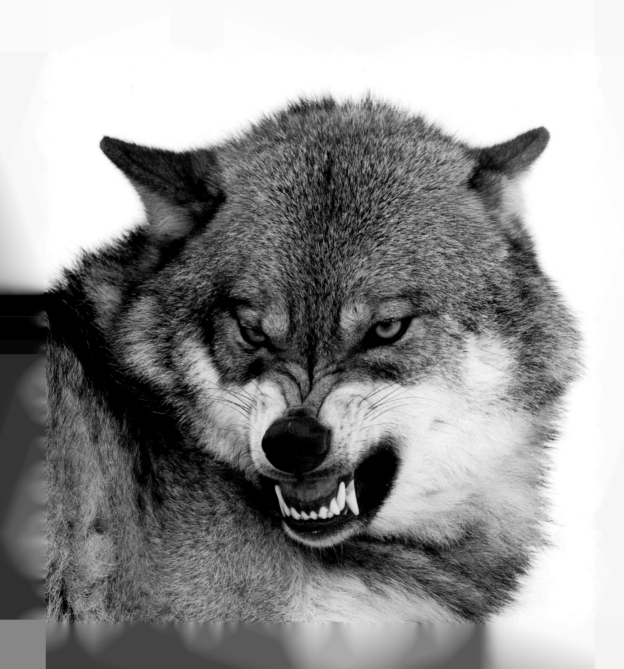

THROUGHOUT THE CENTURIES

WE HAVE PROJECTED ON TO

THE WOLF THE QUALITIES WE

MOST DESPISE AND FEAR

in ourselves.

[BARRY LOPEZ]

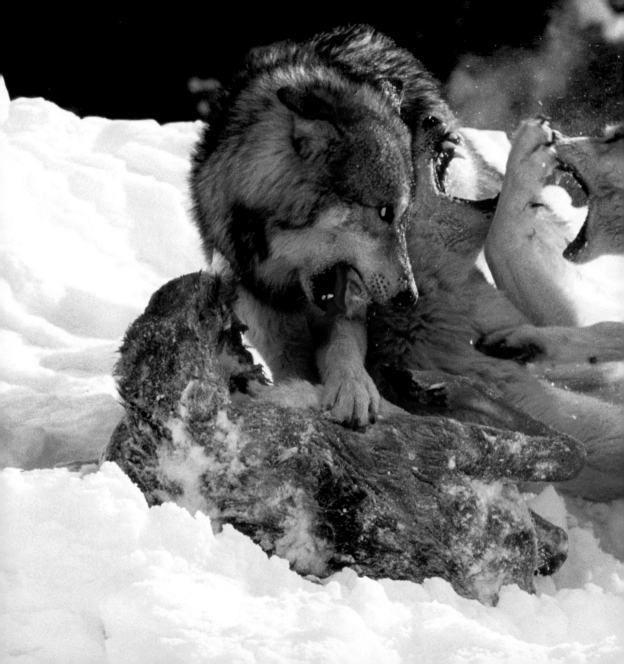

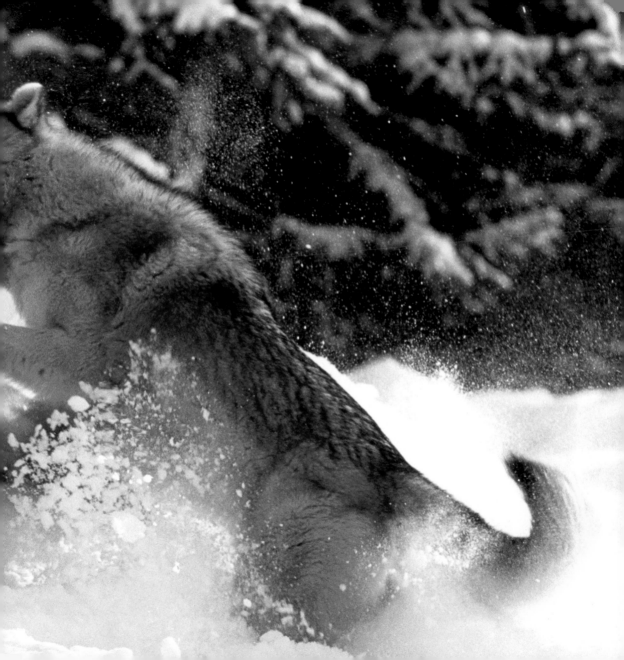

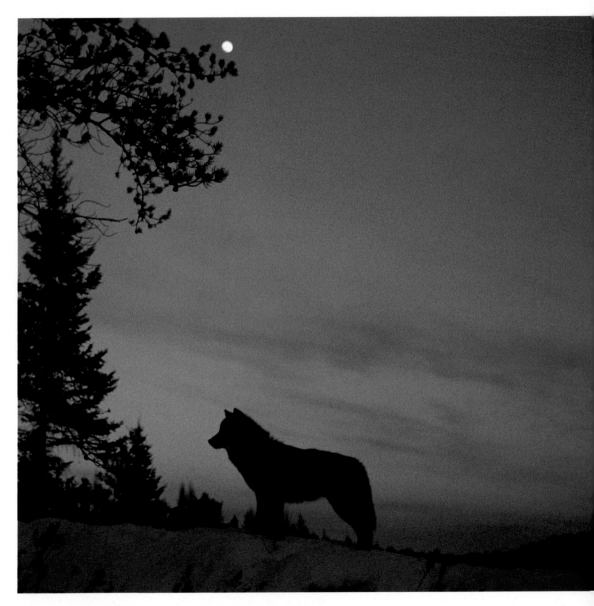

WE DO NOT UNDERSTAND OURSELVES YET

AND DESCEND FARTHER FROM HEAVEN'S AIR

IF WE FORGET HOW MUCH THE NATURAL

WORLD MEANS TO US. SIGNALS ABOUND

THAT THE LOSS OF LIFE'S DIVERSITY

ENDANGERS NOT JUST THE BODY

but the spirit.

[EDWARD O. WILSON]

EVERY MAJOR PREDATOR IN NORTH AMERICA, FROM MOUNTAIN LIONS
TO GRIZZLY BEARS, WILL OCCASIONALLY STRIKE OUT AT HUMANS, BUT
WOLVES JUST DON'T... PERHAPS THE ANSWER LIES IN THE PECULIAR

similarities between our species.

WE ARE BOTH, AFTER ALL, SOCIAL PREDATORS WHO HAVE EVOLVED
OVER THE EONS IN SMALLISH BANDS DESIGNED TO KILL
EFFICIENTLY. SUCH A KINSHIP OF PROFESSION IS INESCAPABLE.

IT IS, NO DOUBT, ALSO THE REASON WHY TRANSMOGRIFIED WOLVES—
OUR DOMESTIC DOGS—ARE ALONE AMONG MAMMALS IN THEIR ABILITY
TO STIMULATE FEELINGS OF CAMARADERIE AND RECIPROCAL FRIENDSHIP.

[JIM BRANDENBURG]

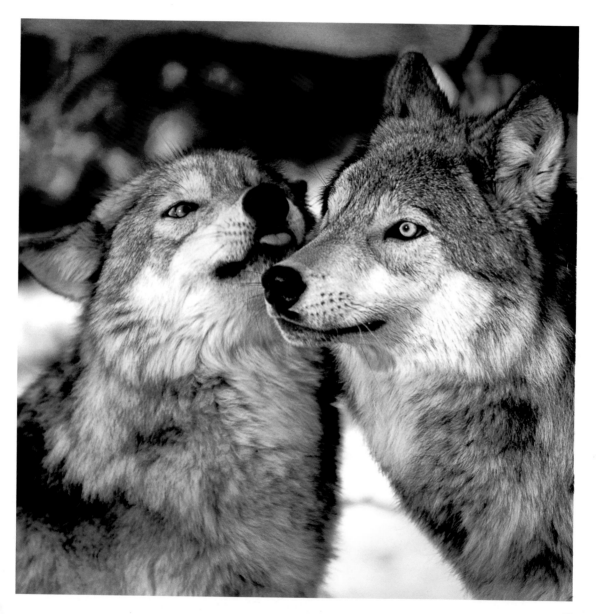

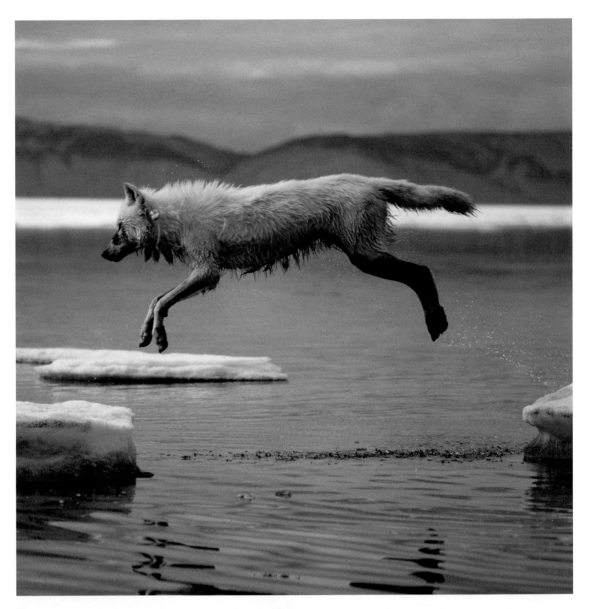

When all the land was covered with water,

THE TRICKSTER WISAGATCAK PULLED UP SOME TREES
AND MADE A RAFT. ON IT HE COLLECTED MANY KINDS
OF ANIMALS SWIMMING IN THE WATERS. THE RAVEN
LEFT THE RAFT, FLYING FOR A WHOLE DAY, AND SAW NO
LAND, SO WISAGATCAK CALLED WOLF TO HELP. WOLF
RAN AROUND AND AROUND THE RAFT WITH A BALL OF
MOSS IN HIS MOUTH. THE MOSS GREW, AND EARTH
FORMED ON IT. IT SPREAD ON THE RAFT AND KEPT
ON GROWING UNTIL IT MADE THE WHOLE WORLD.
THIS IS HOW THE EARTH WAS CREATED.

[FROM THE CREE STORY, EARTH-MAKER WOLF]

WE LISTENED FOR A *voice* CRYING IN THE WILDERNESS.

AND WE HEARD THE JUBILATION OF WOLVES!

[DURWOOD L. ALLEN]

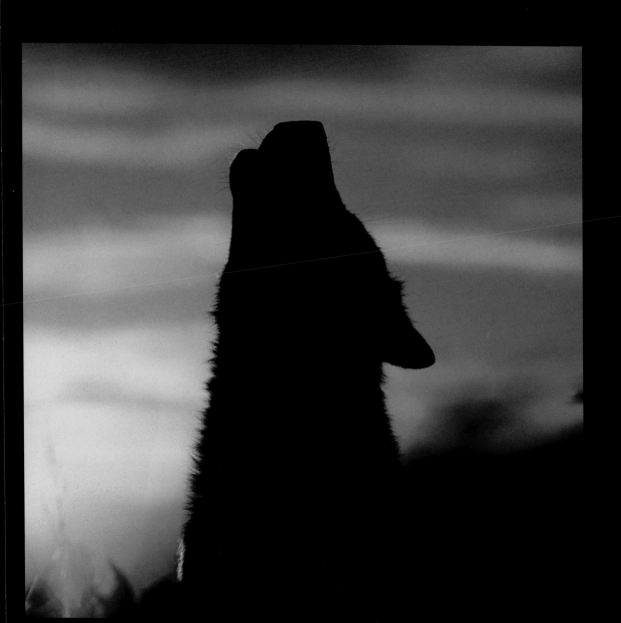

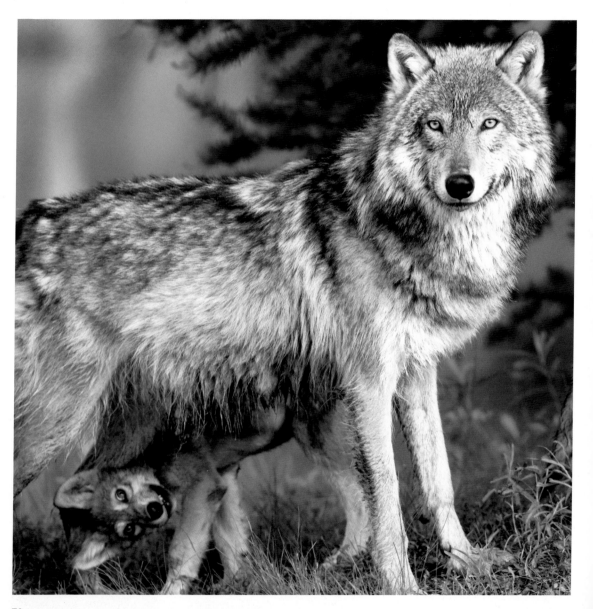

Balance of nature has merits

AND ALSO DEFECTS. ITS MERITS ARE THAT IT CONCEIVES
OF A COLLECTIVE TOTAL, THAT IT IMPUTES SOME UTILITY TO
ALL SPECIES, AND THAT IT IMPLIES OSCILLATIONS WHEN
BALANCE IS DISTURBED. ITS DEFECTS ARE THAT THERE IS
ONLY ONE POINT AT WHICH BALANCE OCCURS,
AND THAT BALANCE IS NORMALLY STATIC.

[ALDO LEOPOLD]

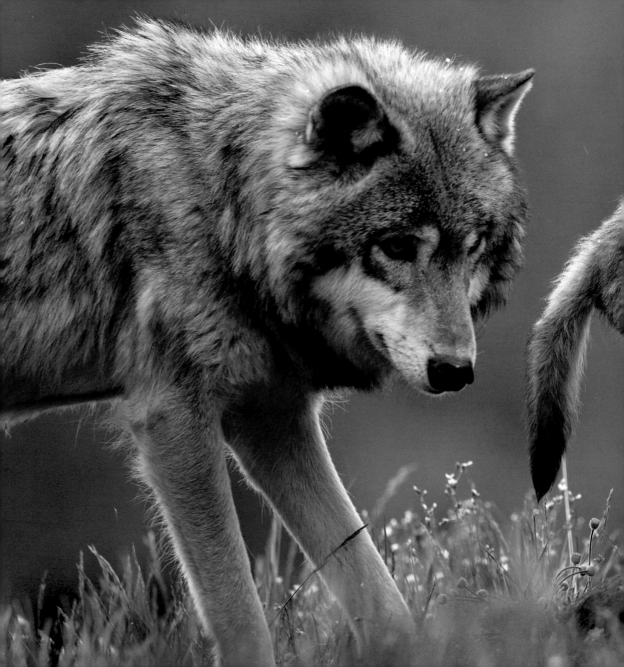

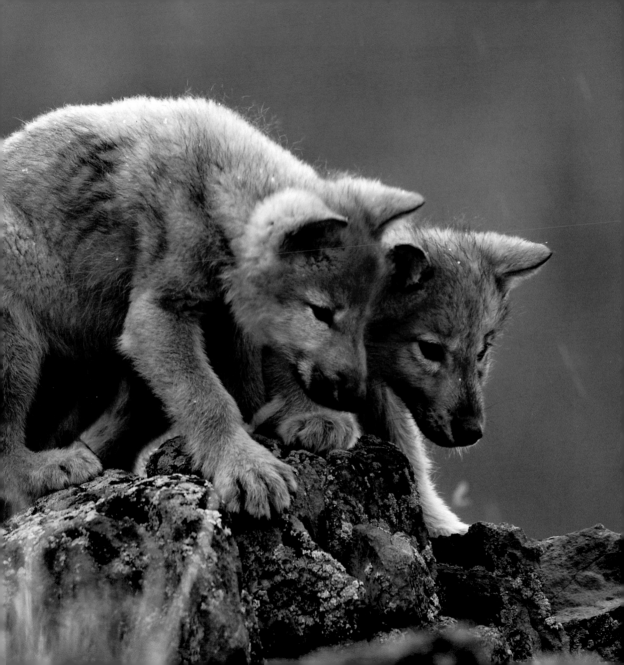

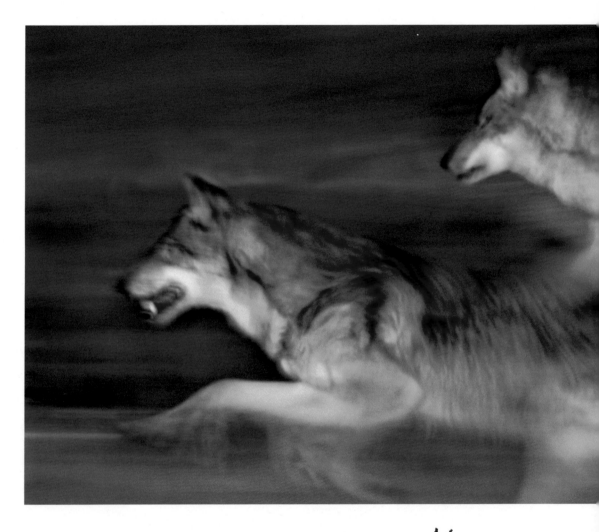

FOR THE STRENGTH OF THE PACK IS THE *wolf,*

AND THE STRENGTH OF THE WOLF IS THE *pack.*

[RUDYARD KIPLING]

IT WAS WILD, UNTAMED MUSIC

and it echoed from the hillsides

AND FILLED THE VALLEYS. IT WAS

A QUEER SHIVERING FEELING

ALONG MY SPINE. IT WAS NOT A

FEELING OF FEAR, YOU UNDERSTAND,

BUT A SORT OF TINGLING, AS IF THERE

WAS HAIR ON MY BACK AND IT WAS HACKLING.

[ALDA ORTON]

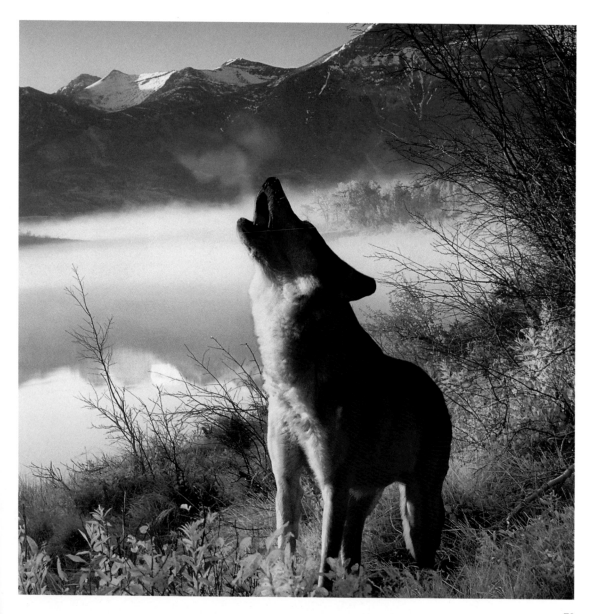

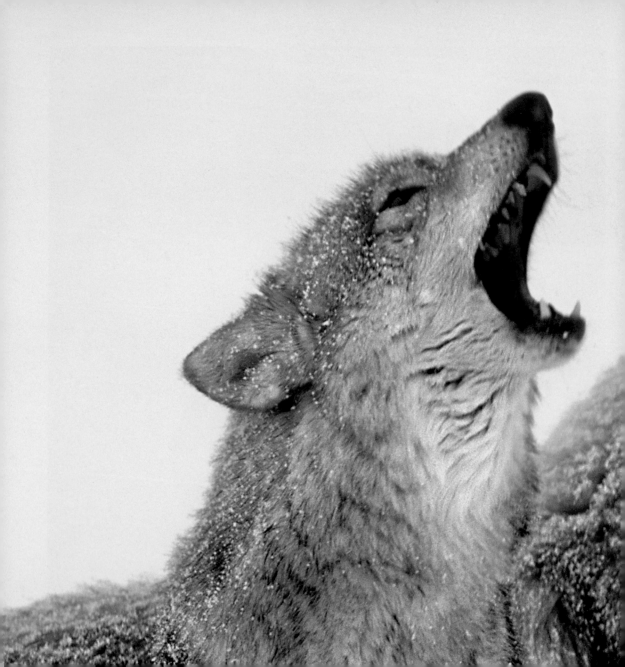

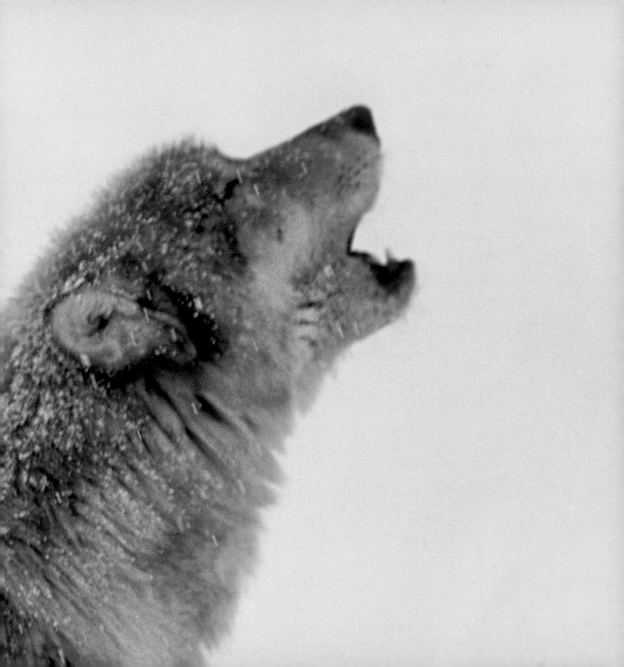

THE CARIBOU FEEDS

THE WOLF,

BUT IT IS THE WOLF

WHO KEEPS

THE CARIBOU

strong.

[KEEWATIN PROVERB]

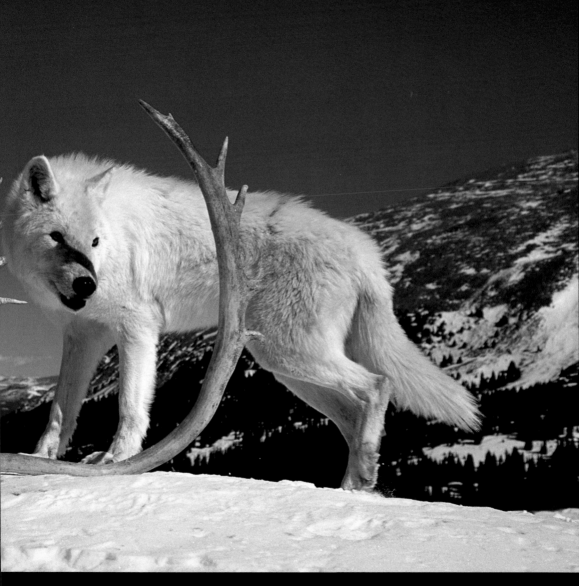

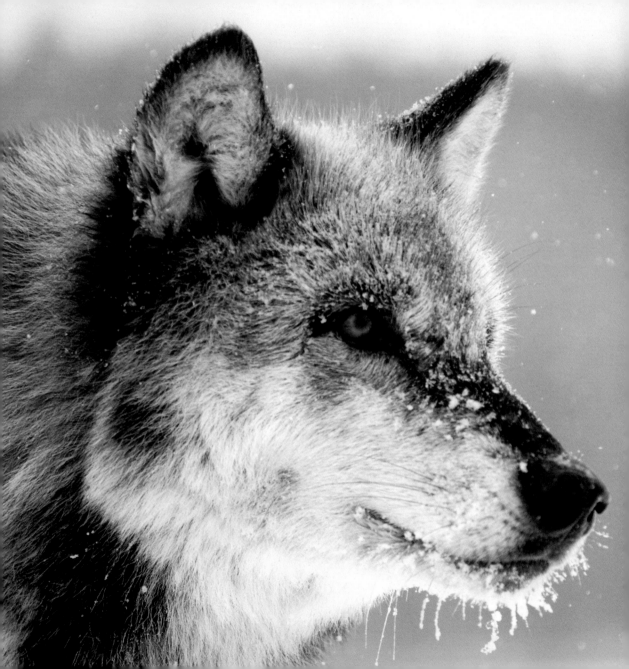

Animal THAT LOOKS LIKE A DOG

BUT IS A POWERFUL *spirit*.

[TRANSLATION OF THE SIOUX INDIAN DESCRIPTION OF THE WOLF, OR SHUNK MANITU TANKA]

WOLVES MAY FEATURE IN
OUR MYTHS, OUR HISTORY
AND OUR DREAMS, BUT THEY
HAVE THEIR OWN FUTURE,
THEIR OWN LOVES,
THEIR OWN DREAMS
to fulfill.
[ANTHONY MILES]

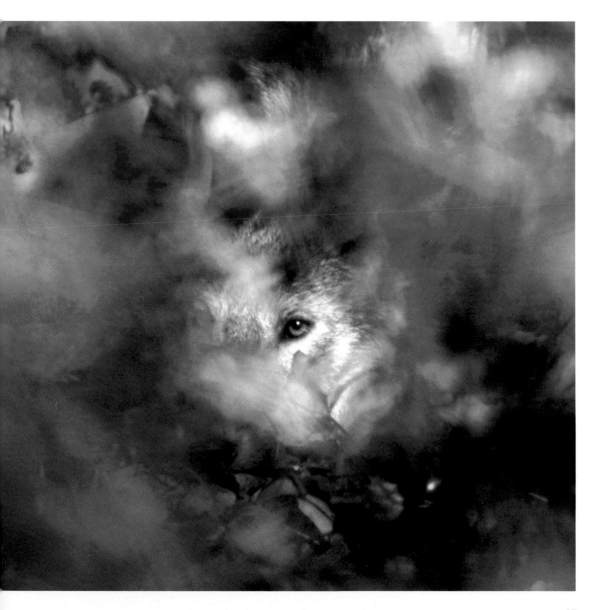

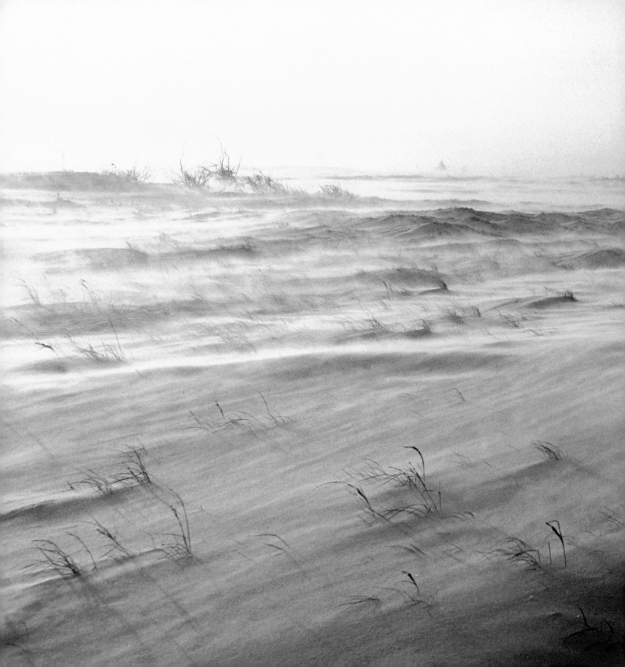

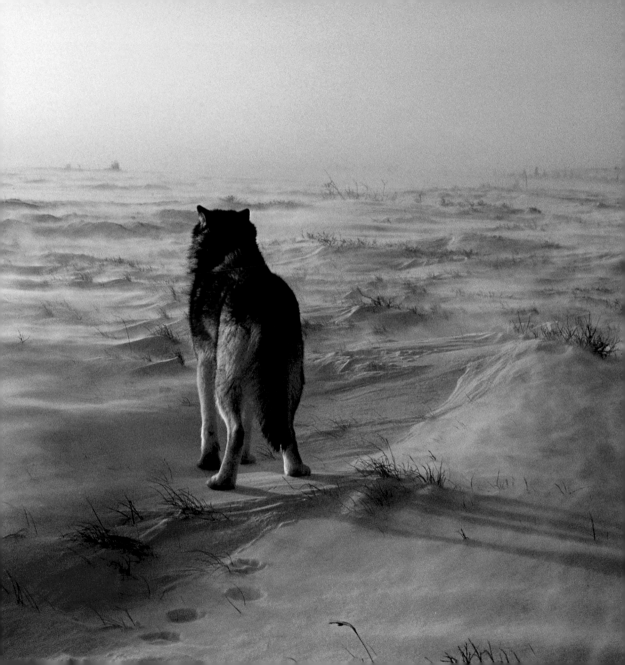

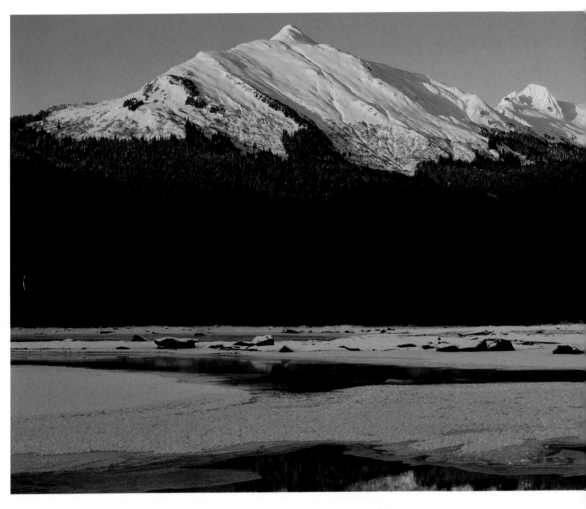

THE THINGS WE WANT TO KILL IN THE WOLF—

freedom, unpredictability—

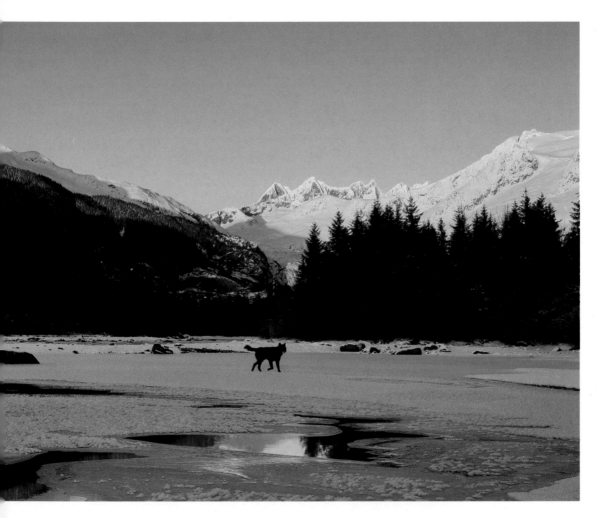

ARE THE THINGS WE BEGIN TO RECOGNIZE THAT
we as people have lost.

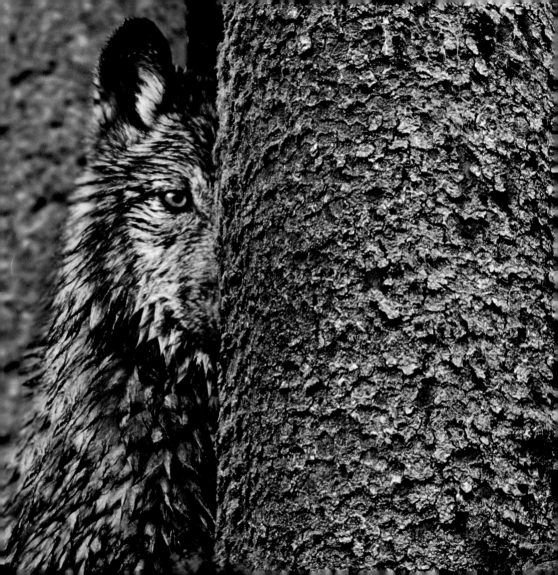

NOW THIS IS THE LAW OF THE JUNGLE—

as old and as true as the sky;

AND THE WOLF THAT SHALL KEEP IT

MAY PROSPER, BUT THE WOLF

THAT SHALL BREAK IT MUST DIE.

[RUDYARD KIPLING]

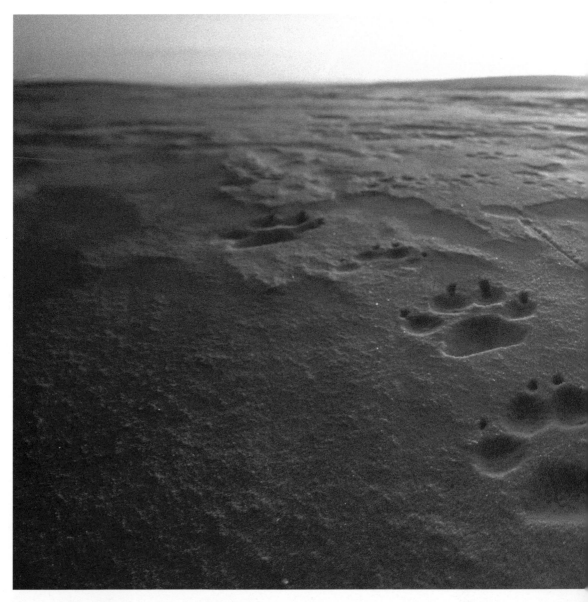

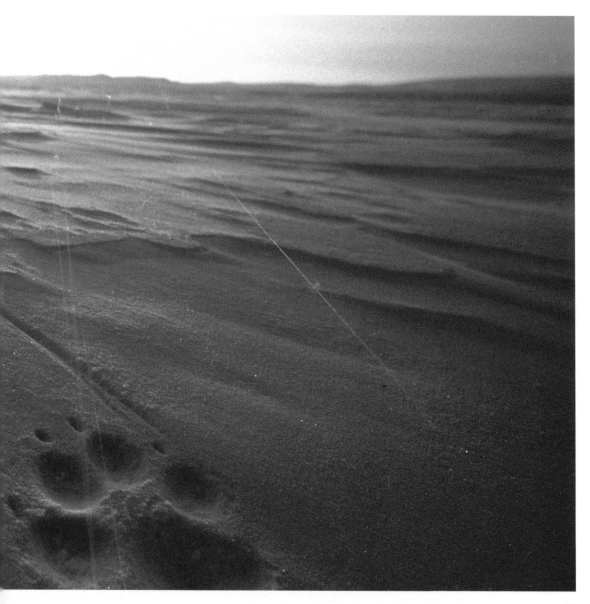